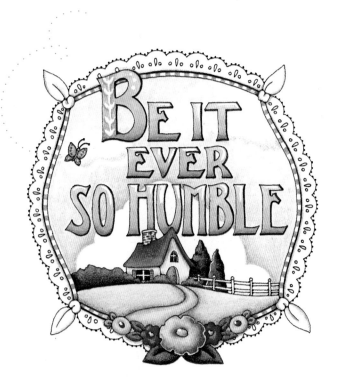

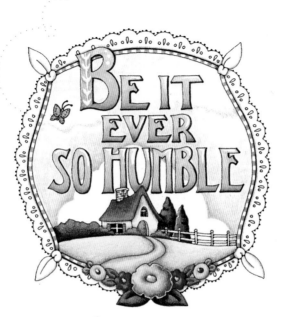

ILLUSTRATED

BY

Mary Engelbreit

**Andrews McMeel
Publishing**

Kansas City

For information, write Andrews McMeel Publishing,
an Andrews McMeel Universal company,
4520 Main Street, Kansas City, Missouri 64111.

www.andrewsmcmeel.com
www.maryengelbreit.com

 and Mary Engelbreit are registered trademarks of
Mary Engelbreit Enterprises, Inc.

02 03 04 05 06 MON 10 9 8 7 6 5 4 3 2 1

Library of Congress Catalog Card Number:
2001095914
ISBN: 0-7407-2085-6

Illustrations by Mary Engelbreit
Design by Becky Kanning

ATTENTION: SCHOOLS AND BUSINESSES
Andrews McMeel books are available at quantity discounts with bulk purchase
for education, business, or sales promotional use.
For information, please write to: Special Sales Department, Andrews McMeel Publishing,
4520 Main Street, Kansas City, Missouri 64111.

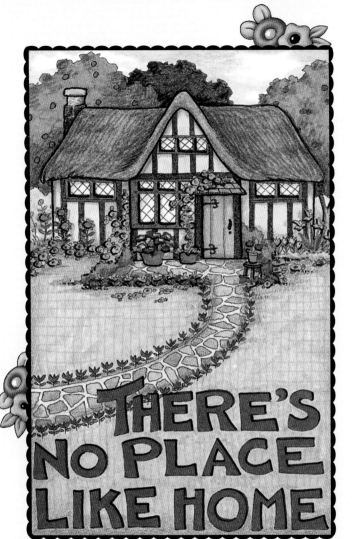

THERE'S NO PLACE LIKE HOME

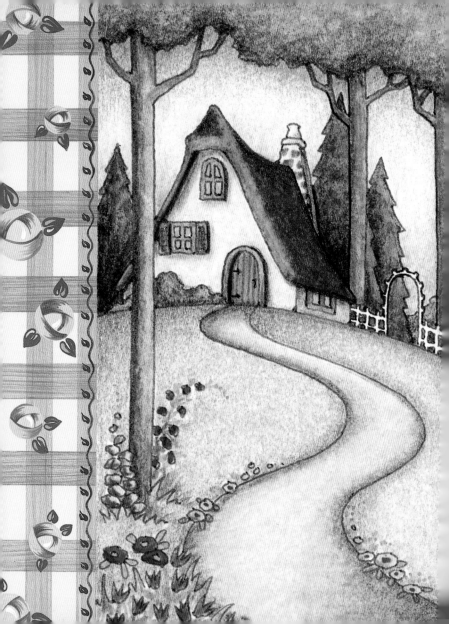

A roof to keep out the rain.
Four walls to keep out the wind.
Floors to keep out the cold.
Yes, but home is more than that.
It is the laugh of a baby,
the song of a mother,
the strength of a father.
Warmth of loving hearts,
light from happy eyes,
kindness,
loyalty,
comradeship.
Home is first school and first church for the young ones,
where they learn what is right,
what is good,
and what is kind.
Where they go for comfort when they are hurt or sick.
Where joy is shared and sorrow eased.
Where fathers and mothers are respected and loved.
Where children are wanted.
Where the simplest food is good enough for kings
because it is earned.
Where money is not so important as loving-kindness.
Where even the teakettle sings from happiness.
That is home.
God bless it.

— ERNESTINE SCHUMAN-HEINK

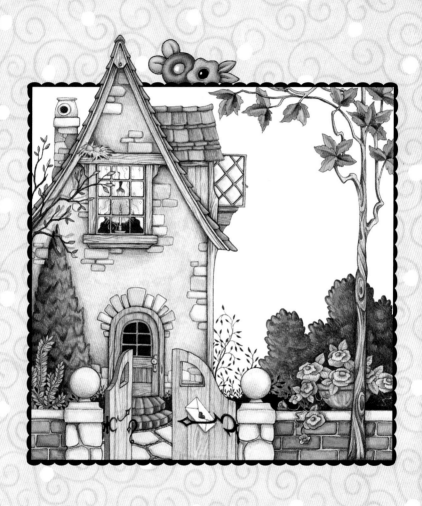

 roof
to keep out
the rain.

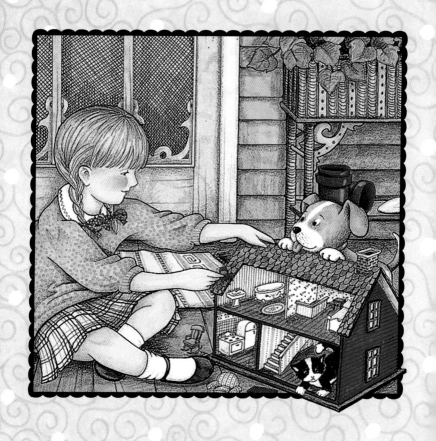

Four walls
 to keep out
 the wind.

Floors to
keep out
the cold.

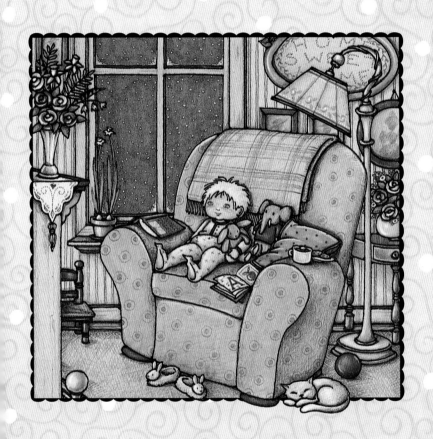

Yes, but home is
more than that.

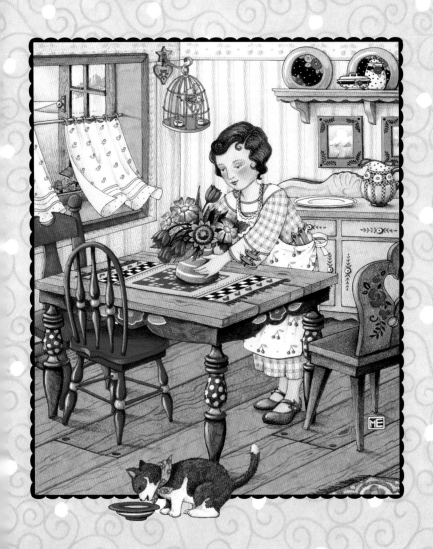

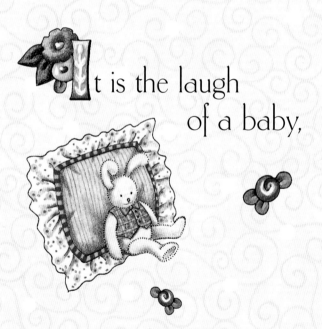

It is the laugh
of a baby,

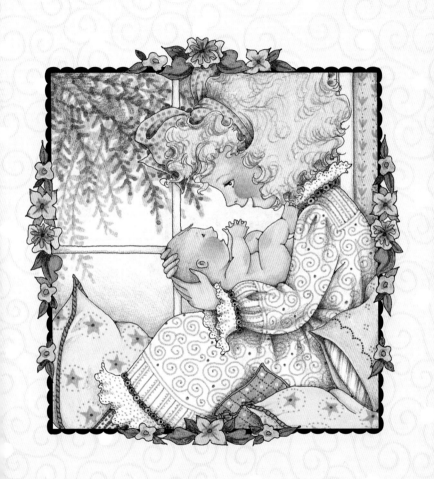

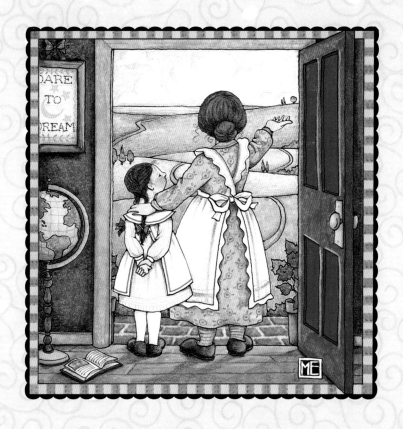

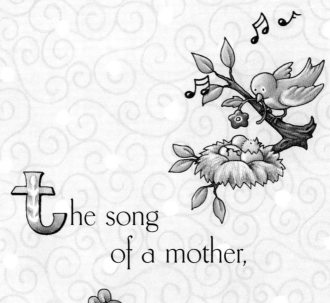

the song
of a mother,

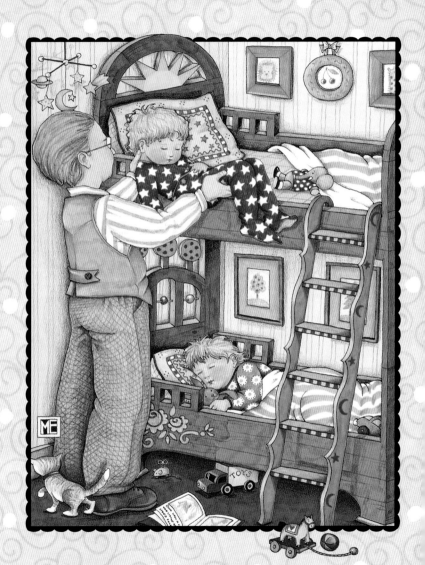

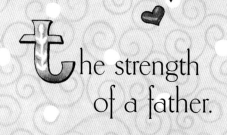

the strength
of a father.

Warmth
of
loving hearts,

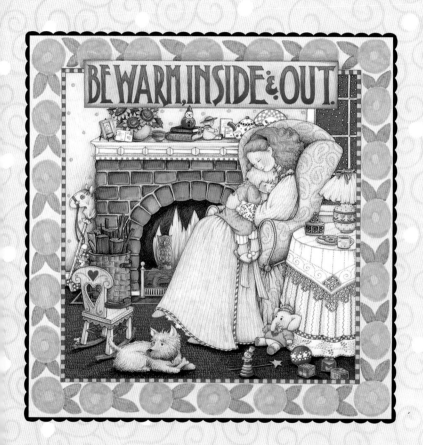

BE WARM, INSIDE & OUT.

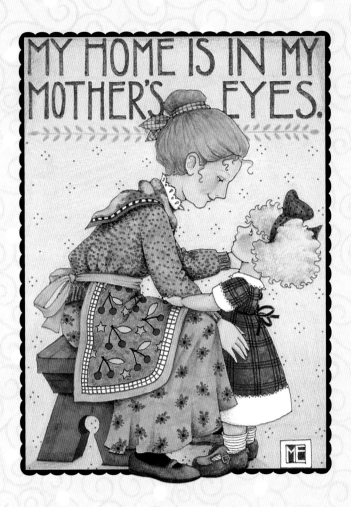

light
from
happy eyes,

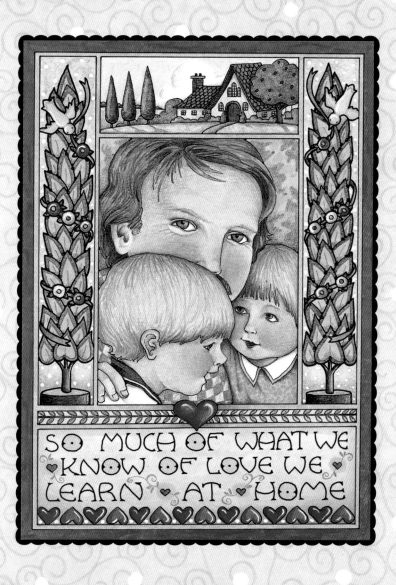

SO MUCH OF WHAT WE
KNOW OF LOVE WE
LEARN · AT · HOME

Kindness,
loyalty,
comradeship.

Home is
first school
and first church
for the young ones,

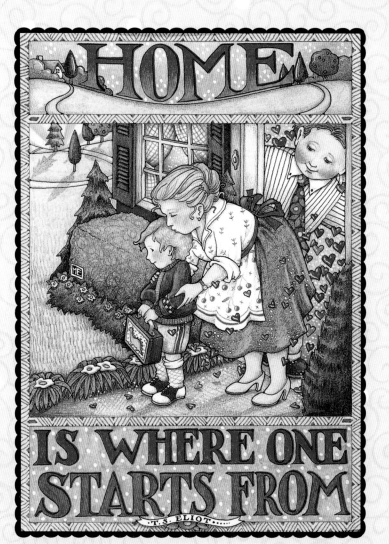

HOME

IS WHERE ONE STARTS FROM

T.S. ELIOT

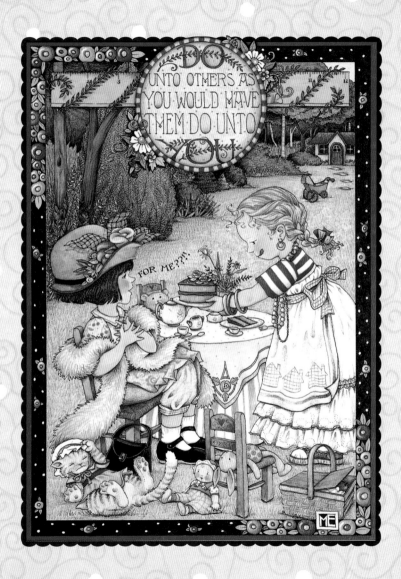

Where they learn
what is right,

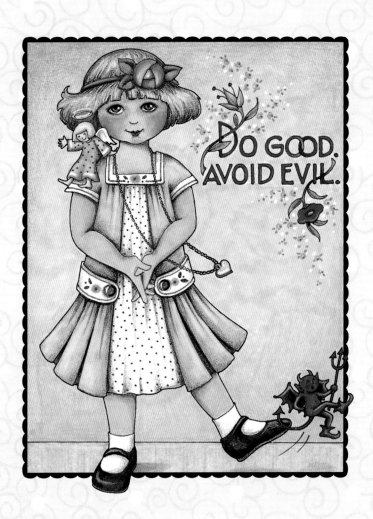

What is good,

And
what
is kind.

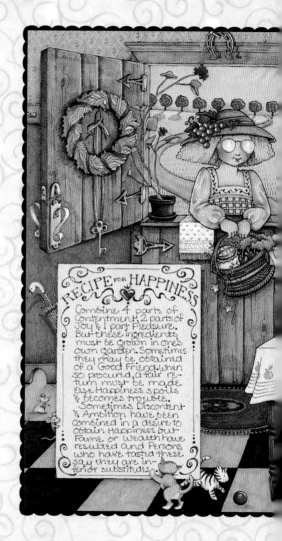

RECIPE FOR HAPPINESS

Combine 4 parts of
Contentment, 2 parts of
Joy & 1 part Pleasure.
But these ingredients
must be grown in one's
own garden. Sometimes
they may be obtained
of a Good Friend. When
so procured, a fair re-
turn must be made.
Else Happiness spoils
& becomes trouble.
Sometimes Discontent
& Ambition have been
combined in a desire to
obtain Happiness but
Fame or Wealth have
resulted and Persons
who have tasted these
say they are in-
ferior substitutes.

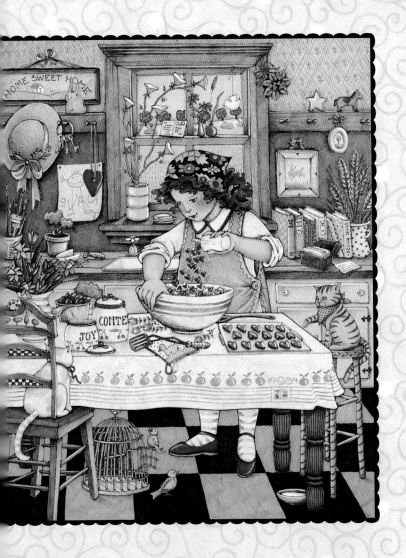

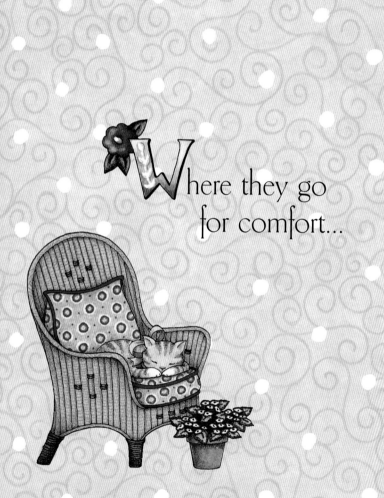

Where they go
for comfort...

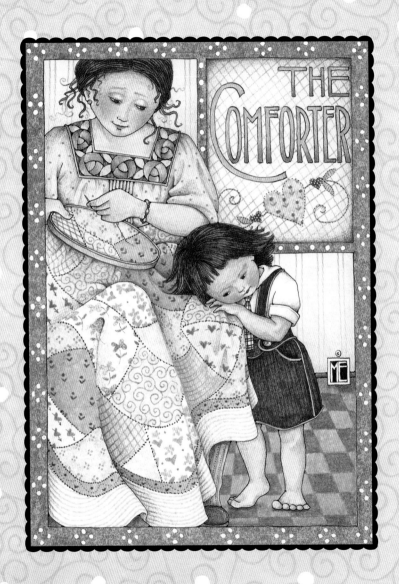

THE COMFORTER

When they are
hurt or sick.

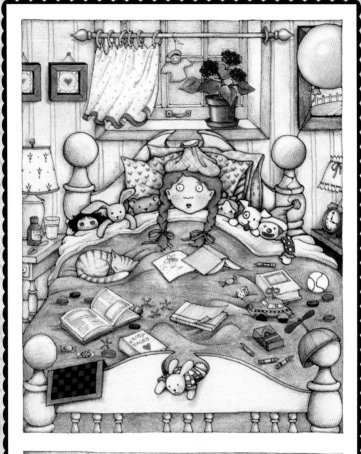

a case of the vapors

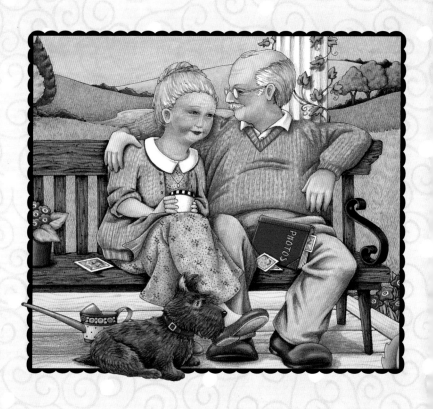

Where joy
is shared...

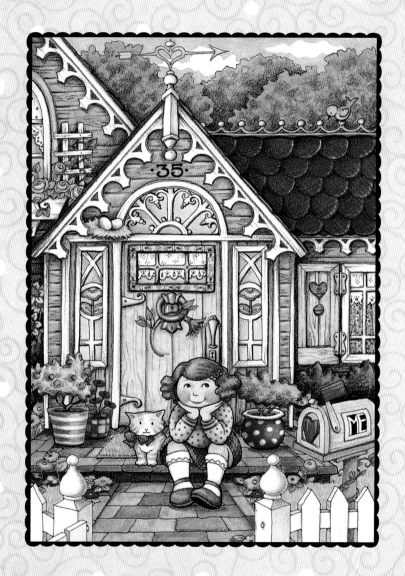

And sorrow eased.

Where fathers
and mothers
are respected
and loved.

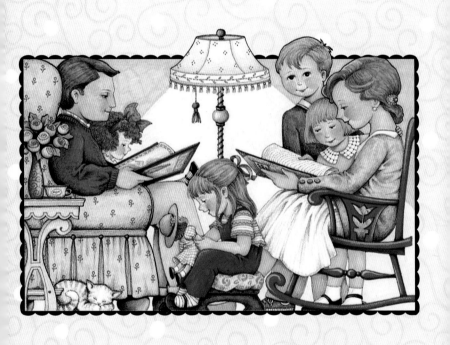

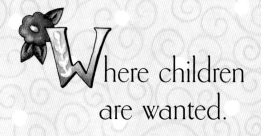

Where children
are wanted.

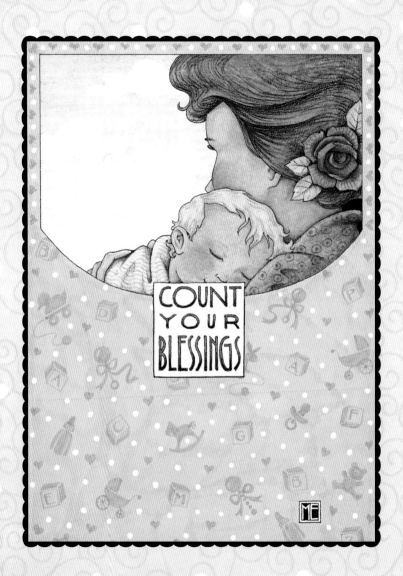

COUNT
YOUR
BLESSINGS

ME

Where the
simplest food
is good enough for kings
because it is earned.

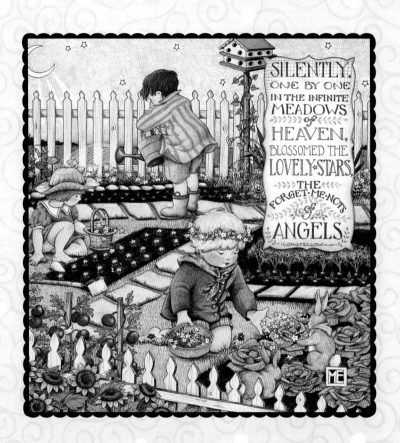

SILENTLY,
ONE BY ONE
IN THE INFINITE
MEADOWS of
HEAVEN,
BLOSSOMED THE
LOVELY·STARS,
THE
FORGET·ME·NOTS
of
ANGELS

·LONGFELLOW·

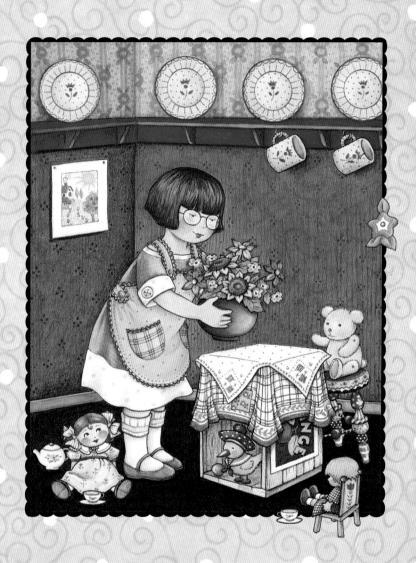

Where money is
not so important...

s loving-kindness.

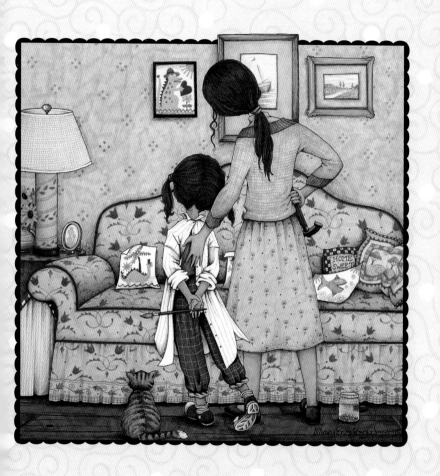

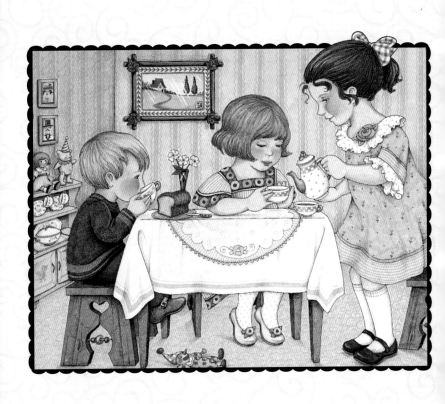

Where even
the teakettle sings
from happiness.

That is home.
God bless it.

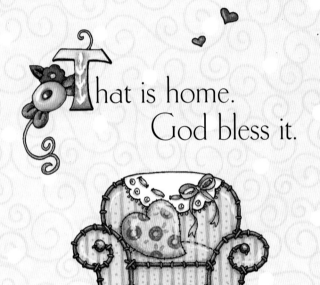

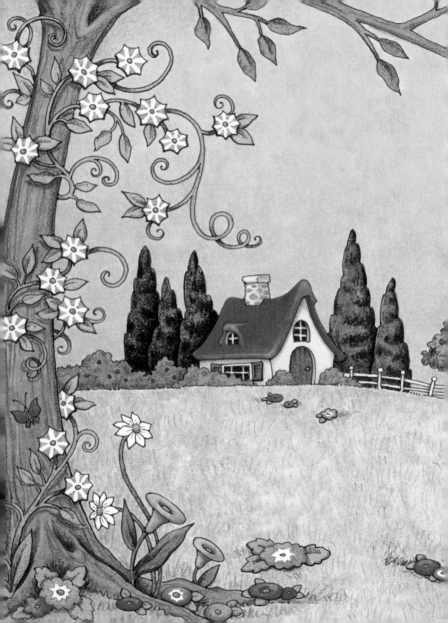